, as he had always and his exid id love xui 6 Tall this year my mechy In hissed me ... (d.

A Running Press Miniature Edition

Copyright © 1992 by Running Press.

All rights reserved under the Pan-American and
International Copyright Conventions.

This book may not be reproduced in whole or in part in any form or by any means, electronic or mechanical, including photocopying, recording, or by any information storage and retrieval system now known or hereafter invented, without written permission from the publisher. The proprietary trade dress, including the size and format of this Running Press.

It may not be used or reproduced without the express written permission of Running Press.

Library of Congress Cataloging-in-Publication Number

ISBN 1-56138-149-7

This book may be ordered by mail from the publisher.

Please include \$1.00 for postage and handling.

But try your bookstore first!

Running Press Book Publishers 125 South Twenty-second Street Philadelphia, Pennsylvania 19103–4399

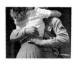

The heart can discern so many kinds of kisses: from the pivotal first peck to the hungry, warm urgency that punctuates a tryst. A kiss is a singular bond, a crystallized moment that embodies the relationship of the kisser to the kissed. In a world where words are easily misconstrued, kisses are eloquent.

Soft and reassuring as butterscotch, a kiss nourishes and warms the soul. It is a confection that never grows tiresome. And when it is over, it lingers on the lips and lives in memory.

Talking about kissing is like humming about fire. Words are insufficient to

describe the experience. Still we try, because kissing is an experience that must be shared.

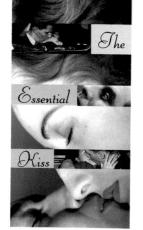

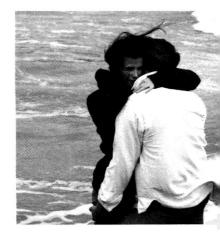

Soul meets soul on lovers lips.

Percy Bysshe Shelley (1792–1822) English poet

Oh, they loved dearly; their souls kissed, they kissed with their eyes, they were both but one single kiss!

Heinrich Heine (1797–1856) German poet

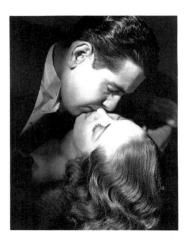

... once he drew

With one long kiss my whole soul thro Why lips, as sunlight drinketh dew.

Alfred, Lord Tennyson (1809–1892)
English poet

What of soul was left, I wonder, when the kissing had to stop?

> Robert Browning (1812–1889) English poet

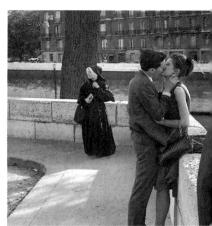

People who throw kisses are mighty hopelessly lazy.

> Bob Hope, b. 1903 American comedian

Occupied the grains of gold or silver found upon the ground, of no value themselves, but precious as showing that a mine is near.

George Villiers (1628–1687) English courtier and dramatist

There is the kiss of welcome and of parting; the long, lingering, loving, present one; the stolen. or the mutual one: the kiss of love, of joy, and of sorrow; the seal of promise and receipt of fulfillment.

Thomas C. Haliburton (1796–1865) Canadian humorist and jurist

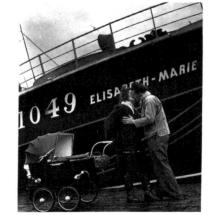

A kiss is something you cannot give without taking and cannot take without giving.

Anonymous

20

A kiss is the shortest distance between two.

> Henny Youngman, b. 1906 English-born American comedian

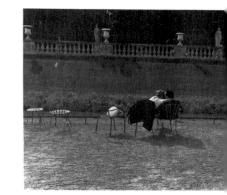

Hisses are like almonds.

Maltese proverb

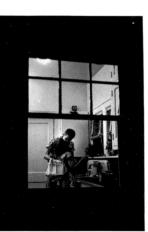

... kisses are a better fate

e.e. cummings (1894–1962) American poet A kiss is a lovely trick designed by nature to stop speech when words become superfluous.

> Ingrid Bergman (1915–1982) Swedish actress

A kiss is the anatomical juxtaposition of two orbicular muscles in a state of contraction.

Cary Grant (1904–1986) [quoting Dr. Henry Gibbons] English-born American actor Fler lips on his could tell him better than all her stumbling words.

> Margaret Mitchell (1900–1949) American writer

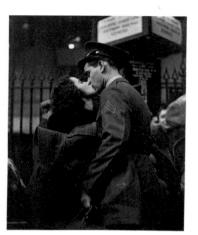

... we embraced each other with-how to say it?-a momentous smiling calm, as if the cup of language had silently overflowed into these eloquent kisses which replaced words like the rewards of silence itself, perfecting thought and gesture.

> Lawrence Durrell (1912–1990) English writer

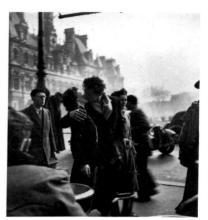

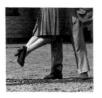

Lord! I wonder what fool it was that first invented kissing.

Jonathan Swift (1667–1745) English satirist The kiss originated when the first male reptile licked the first female reptile, implying in a subtle, complimentary way that she was as succulent as the small reptile he had for dinner the night before.

> F. Scott Fitzgerald (1880-1956) American writer

The decision to kiss for the first time is the most crucial in any love story. It changes the relationship of two people much more strongly than even the final surrender because this kiss already has within it that surrender

> Emil Ludwig (1881–1948) German biographer

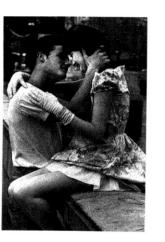

"I don't know how to kiss, or I would kiss you.

Where do the noses go?"

Dudley Nichols Author of the screenplay For Whom The Bell Tolls, based on the novel by Ernest Hemingway I have found men who didn't know how to kiss. I've always found time to teach them.

> Mae West (1893–1980) American actress

carlett, you need kissing badly. That's what's wrong with you.... You should be kissed and by someone who knows how."

"And I suppose you think you are the proper person?" she asked...

"Oh, yes, if I cared to take the trouble," he said carelessly. "They say I kiss very well...take heart. Some day, I will kiss you and you will like it. But not now, so I beg you not to be too impatient."

Gone With The Wind Margaret Mitchell (1900–1949) American writer

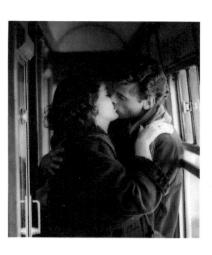

Give me a kiss, and to that kiss a score;
Then to that twenty, add a hundred more:
A thousand to that hundred: so kiss on,
To make that thousand up a million.
Treble that million, and when that is done,
Let's kiss afresh, as when we first begun.

Robert Herrick (1591–1674) English poet Sheir kiss was accompanied by the street organ and it lasted the whole length of the musical score of Carmen, and when it ended it was too late; they had drunk the potion to its last drop. The potion drunk by lovers is prepared by no one but themselves.

> Anaïs Nin (1903–1977) French-born American writer

In delay there lies no plenty;
Then come kiss me, sweet and twenty,
Youth's a stuff will not endure.

William Shakespeare (1564–1616) English dramatist and poet

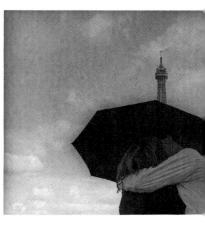

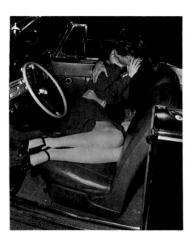

That first night . . . she kissed me. My lips felt so hot, I thought they would burst into flames. She held me and wanted to do more, but I was too frightened, just a fumbling schoolboy of fourteen.

> Kirk Douglas, b. 1916 American actor

... my "first" kiss.... I actually asked her permission. She sighed, as in resignation, and then with some impatience she closed her eyes, puckered her lips and then opened them only long enough to say, "Okay, but make it quick," whereupon we engaged in the briefest and driest moment in all erotica.

> Phil Donahue, b. 1935 American talk-show host

We hadn't been able to see from our position whether the kiss had actually happened, but when Frankie told us it was safe to come out, he swore it had.

"What's it like?" I asked.

"It tastes like chewing gum," Frankie replied.

Russell Baker, b. 1924 American journalist

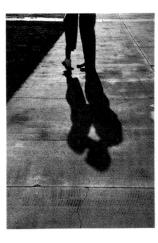

The kissing game I most vividly remember was called Seven Minutes in Heaven. The two players went into the closet where they were supposed to find celestial bliss by spending seven minutes kissing. Of course, there was no ... clock in the closet: just a boy and girl who wondered why they were feeling less passion than fear. . .

> Bill Cosby, b. 1937 American actor

I think he is going to kiss me. I wonder how I will breathe. I remember ... it's much better not to think things through too much, just to do them. So I do.... He kisses me.... His closeness must have an antihistamine effect, because, though we kiss for a long time, I am able to breathe.

> Ellyn Bache 20th-century American writer

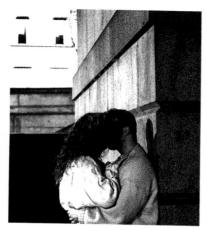

Women still remember the first kiss after men have forgotten the last.

Remy de Gourmont (1858–1915) French novelist and philosopher A recent study shows that, among men, 99 percent report that their first kiss was exciting; among women, only 76 percent found their first kiss exciting.

Louis Rukeyser, b. 1933 American financial broadcaster You are always new. The last of your kisses was ever the sweetest... John Keats (1795–1821) English poet

Kissing power is stronger than will power...

Abigail Van Buren, b. 1918 American columnist

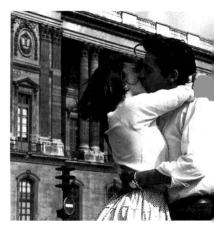

Love at the lips was touch As sweet as I could bear.

Robert Frost (1874–1963) American poet

The moment eternal just that and no more-When ecstasy's utmost we clutch at the core. While cheeks burn arms open, eyes shut, and lips meet! Robert Browning (1812-1889)

English poet

The naked promise in a glance, the electricity in a touch, the delicious heat in a kiss...

> Trudy Culross 20th-century American writer

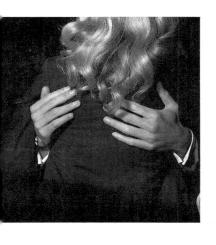

Mhen we reached the place for goodnight I could not let him go as he had always done before, but put my hands round his head and drew it down to mine and kissed his mouth and looked close into his eyes. And...he caught me in his arms and pressed me to him and kissed my mouth and my eyes and my neck; blindly and fiercely he kissed

me.... When I was in bed I could not sleep, but lay trembling half with fear, half with wonder, at what I had awakened in him.

Helen Thomas 19th-century English writer

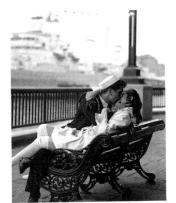

... The bowed his head and joined her lips to his.... It was too much for him. He closed his eyes, surrendering himself to her, body and mind, conscious of nothing in the world but the dark pressure of her softly parting lips.

> James Joyce (1882-1941) Irish writer

It was a strange sensation, a clumsy stumbling falling being caught, the broad sunlit world narrowing to the dark focus of his cushiony lips on mine. It scared me to death, but still I discovered how much I had been waiting for it.

Jane Smiley, b. 1949 American writer

As we were sitting together, suddenly there came into her eyes a look that I had never seen there before. My lips moved towards hers. We kissed each other. I can't describe to you what I felt at that moment. It seemed to me that all my life had been narrowed to one perfect moment of rosecoloured joy.

> Oscar Wilde (1854-1900) British writer

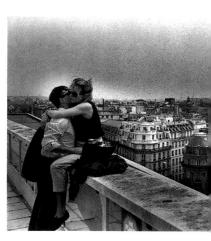

Was this the face that launched
a thousand ships
And burnt the topless towers of Ilium?
Sweet Helen, make me immortal
with a kiss!

Her lips suck forth my soul; see where it flies!

Come Helen, give me my soul again.

Here I will dwell, for Heaven is in these lips....

Christopher Marlowe (1564–1593) English dramatist ... she lifted her face suddenly to him, and he touched it with his lips. So cold, so fresh, so seaclear her face was, it was like kissing a flower that grows near the surf.

> D.H. Lawrence (1885–1930) English writer

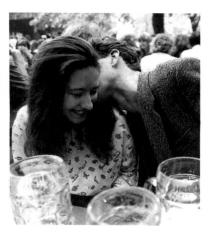

The kiss in the taxi
... remains in the memory as perpetu-

ally unfinished and to be sought out again, for as the taxi moves it gives to the moment that physical proof of insecurity and ephemeralness of adventure, over swift, arousing resonances which cease at first stop....

The adventure continues in the head,

in the body.... Until the next taxi ride no kiss will have that flavor of life and time slipping by, uncapturable, unseizable.

> Anaïs Nin (1903–1977) French-born American writer

He bent his face towards hers. She closed her eyes again and the lids fluttered with a sudden tremulous movement at the touch of his light kiss.

> Aldous Huxley (1894-1963) English writer

Being kissed on the back of the knee is a moth at the windowscreen . . .

> Anne Sexton (1928–1974) American poet

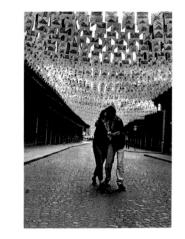

To be thy lips is a sweet thing and small.

> e.e. cummings (1894–1962) American poet

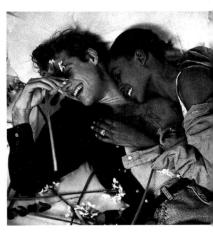

Alfred Eisenstaedt, Life Magazine © 1945 Time Warner Inc.: 133. © 1992 Larry Fink: 67. © 1992 Deborah Hood/ Portfolio Gallery: 37. Carl Iwasaki, Life Magazine © Time

Warner Inc.: 117. Carl Iwasaki, Life Magazine © 1954 Time

Warner Inc.: 24. Carl Iwasaki, Life Magazine © 1961 Time Warner Inc.: 52. © 1981 Pierre Michaud/Rapho/Black Star:

46-7. © 1992 Chris Nash/Portfolio Gallery: 125. © Photoworld 1991/FPG International: 103. © 1949 Willy Ronis/ Rapho/Black Star: 19. © 1957 Willy Ronis/Rapho/Black

1992 Steve Singer: 22-3, 74-5. © Stock Boston, Inc., 1989/ vasi: 79. © Stock Boston, Inc., 1991/John Lei: 136. © 1992 Trevor Watson/Portfolio Gallery: 111. © 1992 Hywel Williams/Portfolio Gallery: 8-9, 55, 69 [detail]. Werner Wolff/

Black Star: 135.

Star: 98-9. © 1987 Michel Sfez/Rapho/Black Star: 84. © Owen Franken: 119. © Stock Boston, Inc., 1990/Akos SzilThe publisher gratefully acknowledges the permission of the following to reproduce the photographs in this book, on the pages indicated:

on the pages indicated:
American Stock Photography: [details] 1, 7, 33, 59, 93, 115;
48. Archive Photos/American: [details] 1, 7, 33, 59, 93, 115.

Archive Photos/American Stock Photography: [details] 1, 7, 33, 59, 81, 93, 115. Archive Photos/Camerique: [details] 1, 7, 33, 59, 93, 115; 11. Archive Photos/Lambert: [details] 3, 34. © 1960s Dominique Berretty/Rapho/Black Star:

130-1. © 1975 Edouard Boubat/Rapho/Black Star: 14-15. © 1975 Edouard Boubat/Rapho/Black Star: 14-15. © 1992 Alwyn Coates/Portfolio Gallery: 42, 60, 70, 127. © 1992 Chris Dawes/Portfolio Gallery (details) 41, 129; 86 © 1050 Palvar Davison (Paul Montal) 14, 129;

© 1992 Chris Dawes/Portfolio Gallery: [details] 41, 129; 86 © 1950 Robert Doisneau/Rapho/Black Star: 31, 95, 122. © 1958 Robert Doisneau/Rapho/Black Star: 113. © 1990 Robert Doisneau/Rapho/Black Star: 62–3. Alfred Eisenstaedt, Life Magazine © 1943 Time Warner Inc.: 29. ...then I did the simplest
thing in the world.
I leaned down...
and kissed him.
And the world

Agnes de Mille, b. 1905 American choreographer and dancer

cracked open.

The universe hangs on a kiss, exists in the hold of a kiss.

Zalman Shneor 19th-century Russian-Israeli poet With a kiss let us set out for an unknown world.

> Alfred de Musset (1810–1857) French poet

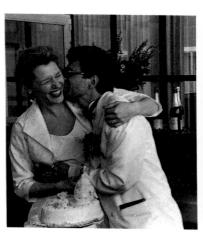

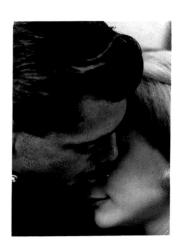

... the promise of such kisses... where would it carry us?... No-one could tell what lay beyond the closed chapter of every kiss.

Lawrence Durrell (1912-1990) English writer

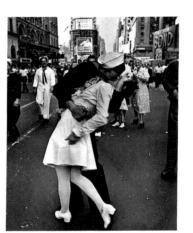

A long, long kiss, —a kiss of youth

and love.

English poet

George Gordon, Lord Byron (1788-1824)

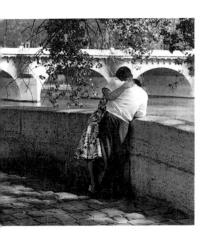

A soft lip would tempt you to eternity of kissing.

Ben Jonson (1573–1637) English dramatist and poet

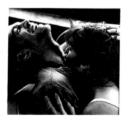

Thousand kisses grant me sweet;
With a hundred these complete;
Lip me a thousand more, and then
Another hundred give again.

A hundred more, then hurry one Kiss after kiss without cessation Until we lose all calculation...

A thousand add to these anon

Catullus (84–54 B.C.) Roman poet

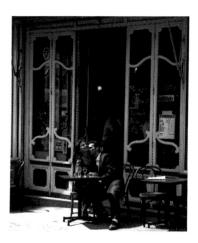

Every kiss provokes another. Ah, in those earliest days of love how naturally the kisses spring to life! So closely, in their profusion, do they crowd together that lovers would find it as hard to count the kisses exchanged in an hour as to count the flowers in a meadow

> Marcel Proust (1871–1922) French writer

in May.

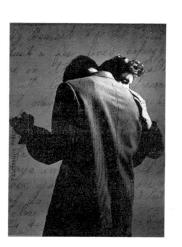

If I were what the words are, And love were like the tune, With double sound and single Delight our lips would mingle, With kisses glad as birds are That get sweet rain at noon . . .

> Algernon C. Swinburne (1837–1909) English poet

...we kiss.

And it feels
like we
have just
shrugged off
the world.

Jim Shahin 20th-century American writer and editor

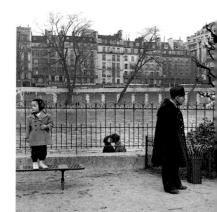

hand in hand.

Where one drop of blood drains a castle of life, so one kiss can bring it alive again.

The Sleeping Beauty by the Brothers Grimm, retold by Trina Schart Hyman 20th-century writer and illustrator

There she lay, amidst the dust and the cobwebs looking so

shining and beautiful and merry . . . that he knelt down beside her and gave her a kiss.

As soon as he touched her, the spell was broken; Briar Rose opened her eyes and looked wonderingly at him . . . they went down from the tower together,

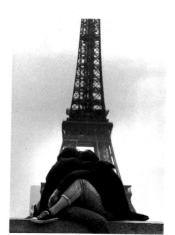

I dreamt my lady came and found me dead,—

Strange dream, that gives a dead man leave to think!—

And breathed such life with kisses in my lips,

That I revived, and was an emperor.

William Shakespeare (1564-1616) English dramatist and poet

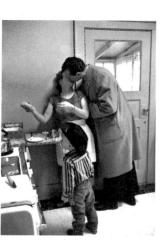

... the kisses, which bring me back to life.

George Sand [Amandine A. L. Dupin] (1804–1876) French writer

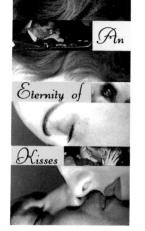

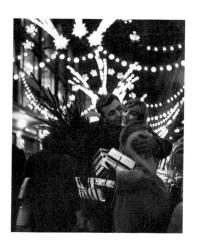

"Then let us kiss once more, as travellers setting out."

When she had done as he asked and knew that her lips would not touch his again and that between them the recognitions of love were ended, she felt him take her hand and kiss it. Then, knowing herself released, she turned away...

Charles Morgan (1894–1958) English novelist and critic

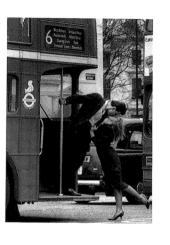

That farewell kiss which resembles greeting, that last glance of love which becomes the sharpest pang of sorrow.

> George Eliot [Mary Ann Evans] (1819–1880) English writer

Cinderella, dressed in yellow,
Went upstairs to kiss her fellow.
But instead she kissed a snake—
How many doctors did it take?
One, two, three, four . . .
Traditional children's jump-rope rhyme

Everybody winds up kissing the wrong person goodnight.

Andy Warhol (1927–1987) American artist A man had given all other bliss, Find all his worldly work for this, To waste his whole heart in one kiss, Upon her perfect lips.

> Alfred, Lord Tennyson (1809–1892) English poet

There are swords about me to keep me safe:

They are the kisses of your lips.

Mary Carolyn Davies 20th-century American poet You may conquer with the sword, but you are conquered by a kiss.

Daniel Heinsius (1580–1655) Dutch philologist and poet ... is there still more in store for me when, yielding to the profound feelings which overwhelm me, I draw from your lips, from your heart, a love which consumes me with fire?

> Napoleon Bonaparte (1769–1821) French Emperor

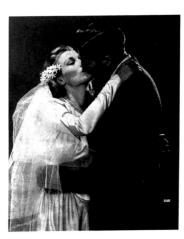

G cease not from desire till my desire
Is satisfied; or let my mouth attain
My love's red mouth, or let my soul
expire,

Sighed from those lips that sought her lips in vain

Hafiz (1320-1391) Persian poet The sunlight clasps the earth

And the moonbeams kiss the sea:

What are all these kissings worth

If thou kiss not me?

Percy Bysshe Shelley (1792–1822) English poet Mistake me not—unto my inmost core
I do desire your kiss upon my mouth,
They have not craved a cup of water more
That bleach upon the deserts of
the south...

American poet

Edna St. Vincent Millay (1892-1952)

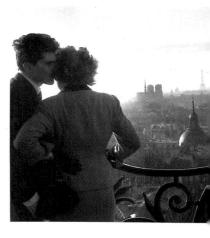

When I tried to draw near, you dissolved into air before my lips could touch you.

> George Sand [Amandine A. L. Dupin] (1804–1876) French writer

The burned lip will always spurn the flame.

Hugh Morris 20th-century American writer

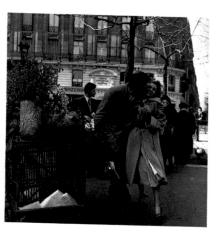

Lips only sing when they cannot kiss.

James Thomson (1834–1882) British poet

Trink to me only with thine eyes,
And I will pledge with mine;
Or leave a kiss but in the cup
And I'll not look for wine.

Ben Jonson (1573–1637) English dramatist and poet I will leave thee when . . .

I have gently stolen from thy lips
Their yet untasted nectar, to allay
The raging of my thirst, e'en as the bee
Sips the fresh honey from the
opening bud.

Kālidāsa Fifth-century Indian dramatist and poet And the roof of thy mouth like the best wine for my beloved, that goeth down sweetly, causing the lips of those that are asleep to speak.

The Song of Solomon

Let him kiss me with the kisses of his mouth: for thy love is better than wine...

Thy lips, O my spouse, drop as the honeycomb: honey and milk are under thy tongue...

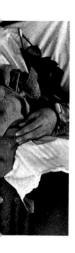

... how she felt when first he kissed her—like a tub of roses swimming in honey, cologne, nutmeg, and blackberries.

Samuel Sullivan Cox (1824–1889) American writer and Congressman